Embracing God with the Life You Never Expected

Laura Krokos

ISBN-13:978-1535055079
ISBN-10:1535055073

All Scripture quotations are taken from the Holman Christian Standard Bible®, Copyright © 1999, 2000, 2002, 2003, 2009 by Holman Bible Publishers.

To order additional copies of this resource, order online at www.MissionalWomen.com

Printed in the United States of America.

Table of Contents

Potiphar's Wife; Life Unrestrained................................3

Woman at the Well; Experiencing God's Grace............................7

Rahab; Ms. Courageous Meet Prince Charming........................ 11

Damaris; Counted Among Them .. 17

Eunice and Her Faithful reward 23

Midwives; Living for Righteousness........................... 26

Miriam; What's the Big Deal With Dishonor? 30

Dinah; When Life is Bigger Than you Imagined........................ 35

Lot's wife; Dealing With a Heart that Longs.............................. 42

Mother of Thunder; When you Want for Your Kids................ 47

Having a Martha Faith in a Mary World........................... 51

The Phoenician Widow and the Blinding Effects of Shame... 57

King Lemuel's Mom & Bragging on Others 62

The Sinful Woman; The Making of a Heronine........................ 64

About the Author ... 69

Potiphar's Wife
Life Unrestrained

Now Joseph had been taken down to Egypt. Potiphar, an Egyptian who was one of Pharaoh's officials, the captain of the guard, bought him from the Ishmaelites who had taken him there.

The Lord was with Joseph so that he prospered, and he lived in the house of his Egyptian master. When his master saw that the Lord was with him and that the Lord gave him success in everything he did, Joseph found favor in his eyes and became his attendant. Potiphar put him in charge of his household, and he entrusted to his care everything he owned. From the time he put him in charge of his household and of all that he owned, the Lord blessed the household of the Egyptian because of Joseph. The blessing of the Lord was on everything Potiphar had, both in the house and in the field. So Potiphar left everything he had in Joseph's care; with Joseph in charge, he did not concern himself with anything except the food he ate.

Now Joseph was well-built and handsome, and after a while his master's wife took notice of Joseph and said, "Come to bed with me!"

But he refused. "With me in charge," he told her, "My master does not concern himself with anything in the

house; everything he owns he has entrusted to my care. No one is greater in this house than I am. My master has withheld nothing from me except you, because you are his wife. How then could I do such a wicked thing and sin against God?" And though she spoke to Joseph day after day, he refused to go to bed with her or even be with her.

One day he went into the house to attend to his duties, and none of the household servants was inside. She caught him by his cloak and said, "Come to bed with me!" But he left his cloak in her hand and ran out of the house.

When she saw that he had left his cloak in her hand and had run out of the house, she called her household servants. "Look," she said to them, "this Hebrew has been brought to us to make sport of us! He came in here to sleep with me, but I screamed. When he heard me scream for help, he left his cloak beside me and ran out of the house."

She kept his cloak beside her until his master came home. Then she told him this story: "That Hebrew slave you brought us came to me to make sport of me. But as soon as I screamed for help, he left his cloak beside me and ran out of the house."

When his master heard the story his wife told him, saying, "This is how your slave treated me," he burned with anger. Joseph's master took him and put him in prison, the place where the king's prisoners were confined.

But while Joseph was there in the prison, the Lord was with him; he showed him kindness and granted him favor in the eyes of the prison warden. So the warden put Joseph in

charge of all those held in the prison, and he was made responsible for all that was done there. The warden paid no attention to anything under Joseph's care, because the Lord was with Joseph and gave him success in whatever he did.

Genesis 39 (NIV)

She had it all but even then she still hungered for more. Ecclesiastes says the more we have the more we think we need. I suppose that is why the sweet family in Tanzania Africa, part of the poorest tribe in Africa, was so willing to give me the only bananas they had.

Our desire grows for what we are gazing at and Potiphar's wife was gazing at Joseph. James tells us, when desire conceives it gives birth to death. Potiphar's wife is a perfect example. Her desires grew to the point she pursued him, initiated with him and then her marriage, reputation and the blessing God had brought to her and her family was taken away.

To think our desires won't grow when we keep feeding them is a lie. Whatever you feed grows, whether good or bad. We are either feeding the flesh or the Spirit because we don't live in a stand still world. We are either going toward the Lord or away from Him. There is no in between.

Have you ever been there? Hungering for more of something the Lord hasn't given you? (What is your Joseph?) You're not alone. Potiphar's wife was there. But not only Potiphar's wife, me too. And every other woman

on this planet. We crave. That craving was given to us by the Lord for the Lord. That craving is beautiful when we are craving the right things, or the right person, namely the Lord. He is the only One who will truly fill and satisfy us.

Are you feeding the flesh or the Spirit right now in your craving? Are you setting your heart on the Lord or some other desire? If not the Lord, He's always ready to receive you, to hear you ask Him for strength, to hear you say you want to want Him the most. He is ready to give you all the power and ability necessary if you'll call out and rely on Him.

What does her story show you about God?

Write principles can you derive from her story?

What would it specifically look like for that to play out in your life this week?

Spend some time talking to the Lord about it what He showed you.

Woman at the Well

Experiencing God's Grace

When Jesus knew that the Pharisees heard He was making and baptizing more disciples than John (though Jesus Himself was not baptizing, but His disciples were), He left Judea and went again to Galilee. He had to travel through Samaria, so He came to a town of Samaria called Sychar near the property that Jacob had given his son Joseph. Jacob's well was there, and Jesus, worn out from His journey, sat down at the well. It was about six in the evening.

A woman of Samaria came to draw water.

"Give Me a drink," Jesus said to her, for His disciples had gone into town to buy food.

"How is it that You, a Jew, ask for a drink from me, a Samaritan woman?" she asked Him. For Jews do not associate with Samaritans.

Jesus answered, "If you knew the gift of God, and who is saying to you, 'Give Me a drink,' you would ask Him, and He would give you living water."

"Sir," said the woman, "You don't even have a bucket, and the well is deep. So where do You get this 'living water'? You aren't greater than our father Jacob, are You? He

gave us the well and drank from it himself, as did his sons and livestock."

Jesus said, "Everyone who drinks from this water will get thirsty again. But whoever drinks from the water that I will give him will never get thirsty again—ever! In fact, the water I will give him will become a well of water springing up within him for eternal life."

"Sir," the woman said to Him, "give me this water so I won't get thirsty and come here to draw water."

"Go call your husband," He told her, "and come back here."

"I don't have a husband," she answered.

"You have correctly said, 'I don't have a husband,'" Jesus said. "For you've had five husbands, and the man you now have is not your husband. What you have said is true."

"Sir," the woman replied, "I see that You are a prophet. 20 Our fathers worshiped on this mountain, yet you Jews say that the place to worship is in Jerusalem."

Jesus told her, "Believe Me, woman, an hour is coming when you will worship the Father neither on this mountain nor in Jerusalem. You Samaritans worship what you do not know. We worship what we do know, because salvation is from the Jews. But an hour is coming, and is now here, when the true worshipers will worship the Father in spirit and truth. Yes, the Father wants such people to worship Him. God is spirit, and those who worship Him must worship in spirit and truth."

The woman said to Him, "I know that Messiah[i] is coming" (who is called Christ). "When He comes, He will explain everything to us."

"I am He," Jesus told her, "the One speaking to you."
John 4:1-26

John 4 tells her story. Isn't that just amazing. John 4 tells her story! The God who created soap suds and the thorny lizard, the One who breathed the stars into being, He thinks this story, this beautiful lady's story worth sharing so He wrote it down so we, who live now, can read about it.

Did you know this is the longest conversation recorded in Scripture between Jesus and anyone? And the fact that the Lord chose this special conversation to be recorded with a woman, an outcast woman no less is flat out shocking! God thinks this story is a big deal!

Our vulnerable, disregarded, social outcast lady is not known by her name but by her location and by her sin. But Jesus steps in and changes that. He gives her an honor no one else in the world gets, having the longest recorded conversation with Jesus and ends her story with eternal redemption bragging on her of how many came to know Him because of her.

Something beautiful about Jesus is seen here. He bows to the custom by asking to talk to her husband. Respectable women didn't speak with a man alone in public. So when Jesus asked her to get her husband, He was honoring her, assuring her of His interest in her welfare. He sure does

know how to put us at ease. Just like the women at the well, when we encounter Jesus and see Him as He truly is, we also see ourselves as we truly are which motivates us confess sins openly and share the Gospel freely.

What does her story show you about God?

Write principles can you derive from her story?

What would it specifically look like for that to play out in your life this week?

Spend some time talking to the Lord about it what He showed you.

Rahab

Ms. Courageous Meet Prince Charming

"Joshua son of Nun secretly sent two men as spies from the Acacia Grove, saying, "Go and scout the land, especially Jericho." So they left, and they came to the house of a woman, a prostitute named Rahab, and stayed there.

The king of Jericho was told, "Look, some of the Israelite men have come here tonight to investigate the land." Then the king of Jericho sent word to Rahab and said, "Bring out the men who came to you and entered your house, for they came to investigate the entire land."

But the woman had taken the two men and hidden them. So she said, "Yes, the men did come to me, but I didn't know where they were from. At nightfall, when the gate was about to close, the men went out, and I don't know where they were going. Chase after them quickly, and you can catch up with them!" But she had taken them up to the roof and hidden them among the stalks of flax that she had arranged on the roof. The men pursued them along the road to the fords of the Jordan, and as soon as they left to pursue them, the gate was shut.

Before the men fell asleep, she went up on the roof and said to them, "I know that the Lord has given you this land and that the terror of you has fallen on us, and everyone who lives in the land is panicking because of you. For we have

heard how the Lord dried up the waters of the Red Sea before you when you came out of Egypt, and what you did to Sihon and Og, the two Amorite kings you completely destroyed across the Jordan. When we heard this, we lost heart, and everyone's courage failed because of you, for the Lord your God is God in heaven above and on earth below. Now please swear to me by the Lord that you will also show kindness to my family, because I showed kindness to you. Give me a sure sign that you will spare the lives of my father, mother, brothers, sisters, and all who belong to them, and save us from death."

The men answered her, "We will give our lives for yours. If you don't report our mission, we will show kindness and faithfulness to you when the Lord gives us the land."

Then she let them down by a rope through the window, since she lived in a house that was built into the wall of the city. "Go to the hill country so that the men pursuing you won't find you," she said to them. "Hide yourselves there for three days until they return; afterward, go on your way."

The men said to her, "We will be free from this oath you made us swear, unless, when we enter the land, you tie this scarlet cord to the window through which you let us down. Bring your father, mother, brothers, and all your father's family into your house. If anyone goes out the doors of your house, his blood will be on his own head, and we will be innocent. But if anyone with you in the house should be harmed, his blood will be on our heads. And if you report our mission, we are free from the oath you made us swear."

"Let it be as you say," she replied, and she sent them away. After they had gone, she tied the scarlet cord to the window.

So the two men went into the hill country and stayed there three days until the pursuers had returned. They searched all along the way, but did not find them. Then the men returned, came down from the hill country, and crossed the Jordan. They went to Joshua son of Nun and reported everything that had happened to them. They told Joshua, "The Lord has handed over the entire land to us. Everyone who lives in the land is also panicking because of us."

Joshua 2

When you think of Rahab what are your first thoughts and feelings?

I hope after today you grow to love her as much as I do. The Lord talks about her a lot through at least three different people who lived at different times. Apparently her story is one that all generations need to hear. Perhaps it's because Rahab's story is our story.

Rahab was a prostitute. A prostitute that cared about her family deeply. Most likely that is the reason she is a prostitute. In the ancient world, women often resorted to prostitution if they had no other means of economic support, especially if they were widows or orphans. It's either that or their family starves. Does knowing this change your attitude toward Rahab?

When you read her story, did you notice her multiple acts of crazy courage?

Here's four of them:

1. The spies end up at her place. How cool is that! The providence of God, leads the two guys straight to the only believer in town. Rahab talks to these men about the Lord and takes initiative to invite them to stay at her place at the risk of her families support.

2. She is questioned about the men by orders of the king, with her life on the line. If the king found out, she would be killed. But she protected, defended and stood by the strangers who she had no reason to trust except that their God was the Lord. What an example of standing with our brothers and sisters in Christ when they need it. Even to her/our own hurt.

3. She tells her family about the coming judgement and promise of salvation. Sharing the Gospel with your unbelieving family members can be the hardest group of people to share with, but she boldly, unashamedly shares with them.

4. She lets the men down by a rope. I would be so scared of dropping them on their heads. After all their safety meant her salvation.

All this courage in such a short amount of time. I like her a lot. This beautiful baby Christian seems so fearless. Life dealt her a hard blow but she didn't let that poison her heart

and turn into bitterness. She clings to the Lord, takes Him at His Word, and walks by faith.

And now maybe you're wondering where prince charming fits in. Well, one of these two spies (who apparently aren't very good spies since the King knew they were there on the first day) was Salmon, Prince of Judah. This is the man who Rahab ends up marrying. How cool is that! From prostitute to princess and ultimately the great, great, great so on, grandma of Jesus. This is the kind of transformational business God is up to in people's lives!

Ok, so back to chapter 2. Don't you just wonder what Rahab and Salmon's first meeting was like? Was there attraction? Respect? And for the three days when Salmon and his buddy stayed in the hills, I wonder if it was within eye distance of the red rope. I wonder if he thought about her and her him. Then in Chapter six, he swoops in and rescues her and her family (all that's missing is a white horse).

I said earlier that Rahab's story is our story. We, mankind, are in desperate need of rescue. All the good we do will never outweigh the bad. Only One can rescue us, Prince Jesus who gave his life that we might be rescued from the life that was killing us. But like Rahab had a choice, so do we. We have to choose for ourselves if we are going to believe what the Bible says about God and receive forgiveness and the new life He offers us. And One day soon He will come back on his white horse and make this world right.

If you were in Rahab's shoes, what would be the scariest thing for you to do?

What does her story show you about God?

Write principles can you derive from her story?

What would it specifically look like for that to play out in your life this week?

Spend some time talking to the Lord about it what He showed you.

Damaris

Counted Among Them

As a missionary, we write monthly updates to tell our supporters what God is doing in students' lives. And though we tell the story just as it is, it just seems different on paper. Somehow on paper it just seems more shocking whereas in real life it seemed so normal.

Like a student years back named Cyndi. We were going around the dorm offering to take out trash and we came to her door. She asked us why we were doing this and we said, *"Because Jesus took the trash out of our hearts and we want to be an example of what He can do."* She invited us in saying she couldn't believe we were there and wanted to hear about Jesus. Turned out she had gotten so drunk the night before she was taken to detox where she was pronounced dead from alcohol poisoning. Eventually they got her heart started again and she had just got out of the hospital not long before we came knocking on her door, making her eager to hear the Gospel. She gave her life to Christ not long after. Isn't our Life Giving God amazing!

Reading through Scripture, it is easy to read in the state of wow, just like Cyndi's story. But as you put yourself in the story, it becomes more real. Let's do that for Acts 17 so when we meet Damarius, we will understand her story a bit more clearly.

*Then they traveled through Amphipolis and Apollonia and
came to Thessalonica, where there was a Jewish
synagogue. As usual, Paul went to the synagogue, and on
three Sabbath days reasoned with them from the Scriptures
explaining and showing that the Messiah had to suffer and
rise from the dead: "This Jesus I am proclaiming to you is
the Messiah." Then some of them were persuaded and
joined Paul and Silas, including a great number of God-
fearing Greeks, as well as a number of the leading women.*

*But the Jews became jealous, and they brought together
some scoundrels from the marketplace, formed a mob, and
started a riot in the city. Attacking Jason's house, they
searched for them to bring them out to the public
assembly. When they did not find them, they dragged Jason
and some of the brothers before the city officials, shouting,
"These men who have turned the world upside down have
come here too, and Jason has received them as guests!
They are all acting contrary to Caesar's decrees, saying
that there is another king—Jesus!" The Jews stirred up the
crowd and the city officials who heard these things. So
taking a security bond from Jason and the others, they
released them.*

*As soon as it was night, the brothers sent Paul and Silas off
to Berea. On arrival, they went into the synagogue of the
Jews. The people here were more open-minded than those
in Thessalonica, since they welcomed the message with
eagerness and examined the Scriptures daily to see if these
things were so. Consequently, many of them believed,
including a number of the prominent Greek women as well
as men. But when the Jews from Thessalonica found out*

that God's message had been proclaimed by Paul at Berea, they came there too, agitating and disturbing the crowds. Then the brothers immediately sent Paul away to go to the sea, but Silas and Timothy stayed on there. Those who escorted Paul brought him as far as Athens, and after receiving instructions for Silas and Timothy to come to him as quickly as possible, they departed.

While Paul was waiting for them in Athens, his spirit was troubled within him when he saw that the city was full of idols. So he reasoned in the synagogue with the Jews and with those who worshiped God and in the marketplace every day with those who happened to be there. Then also, some of the Epicurean and Stoic philosophers argued with him. Some said, "What is this pseudo-intellectual trying to say?"

Others replied, "He seems to be a preacher of foreign deities"—because he was telling the good news about Jesus and the Resurrection.

They took him and brought him to the Areopagus, and said, "May we learn about this new teaching you're speaking of? For what you say sounds strange to us, and we want to know what these ideas mean." Now all the Athenians and the foreigners residing there spent their time on nothing else but telling or hearing something new.

Then Paul stood in the middle of the Areopagus and said: "Men of Athens! I see that you are extremely religious in every respect. For as I was passing through and observing the objects of your worship, I even found an altar on which was inscribed:

TO AN UNKNOWN GOD.

*Therefore, what you worship in ignorance, this I proclaim
to you. The God who made the world and everything in it—
He is Lord of heaven and earth and does not live in shrines
made by hands. Neither is He served by human hands, as
though He needed anything, since He Himself gives
everyone life and breath and all things. From one man He
has made every nationality to live over the whole earth and
has determined their appointed times and the boundaries of
where they live. He did this so they might seek God, and
perhaps they might reach out and find Him, though He is
not far from each one of us. For in Him we live and move
and exist, as even some of your own poets have said, 'For
we are also His offspring.' Being God's offspring then, we
shouldn't think that the divine nature is like gold or silver
or stone, an image fashioned by human art and
imagination.*

*"Therefore, having overlooked the times of ignorance,
God now commands all people everywhere to
repent, because He has set a day when He is going to
judge the world in righteousness by the Man He has
appointed. He has provided proof of this to everyone by
raising Him from the dead."*

*When they heard about resurrection of the dead, some
began to ridicule him. But others said, "We'd like to hear
from you again about this." Then Paul left their presence.
However, some men joined him and believed, including
Dionysius the Areopagite, a woman named Damaris, and
others with them."*

Here's a recap. Paul, Silas and Timothy go to Thessalonica. They go into the synagogue like they normally do when they go to a new city and start teaching about Jesus using Scripture. They were there for three weeks and lots of people turn to Christ (each with amazing stories like Cyndi's I bet. Wont that be fun to hear their stories in heaven!) But some people got jealous, started talking bad about them and got people together and started a riot.

Ok, seriously, if you were Paul, Silas and Timothy, what would you be feeling at this point?

What if you were the brand new believer?

Well the believers go to Paul and Silas when it gets dark and send them away (Would you be one of those people?) and they arrive in Berea. These people are awesome. They *"Received the message with eagerness and examined the Scriptures every day to see if what Paul said was true."* Oh I like them! But then the Jews heard about what was going on and started *"Agitating the crowds and stirring them up."* So again the believers sent Paul away.

So as Paul has just been sent away by believers for speaking truth about Jesus. While he is waiting for his buddies in Athens he sees the city is full of idols. So get this, he is so distressed that he can't help but share the Gospel there too! Is that not awesome!? When was the last time you were in such distress about the things people were putting their hope in that weren't Jesus that you just had to share the Gospel? (Right after being thrown out of cities for sharing it) Paul starts sharing and some guys heard about it and intrigued want to hear more so they invite him to a

special meeting. Paul shares the Gospel there (in a super wise way) and cool things happened as God changes lives and hearts in Athens. As Paul shared the Gospel in this meeting, there were three responses. Those who rejected, those who procrastinated and those who believed, among them was *"a woman named Damaris."*

This truly is an awesome woman. First of all, people thought so highly of her that she was at this meeting. But not only that, she was able to turn to Jesus at this meeting while others *"sneered"*. Though she was well known and it could have been easy to cave under the pressure of wanting people to like her, she choose Jesus instead. I would love to know the rest of her story, but I guess I'll just have to wait till heaven and ask her to share it.

What does her story show you about God?

Write principles can you derive from her story?

What would it specifically look like for that to play out in your life this week?

Spend some time talking to the Lord about it what He showed you.

Eunice

Faithful Reward

I wanted kids ever since I was little. When my husband and I got married we wanted to wait a couple years to have kids. Two years went by and we decided we didn't really want kids but wanted to invest our lives in ministry and have spiritual kids so to say. Two more years went by and the Lord put great examples of moms actively involved in ministry in our path. For the first time I realized being a mom in ministry was possible. So we decided to start having kids. Ha! How much control I thought I had over things like life and death. The Lord sure had to humble me. I honestly thought having kids was all up to us. We'd plan everything and then the Lord would snap His fingers at our desire and poof a baby would appear in my belly. That is obviously not what happened. Two more years went by with no baby in the belly. Instead it was the two week battle of hope climbing and being crushed.

Then the Lord graciously led us to adoption. We had always wanted to adopt but we figured we would adopt "later". (Did you know that of the people who want to adopt, only 3% ever do.) Well, through a series of God ordained events the Lord gave us our two little boys. Then a couple years later as we were pursuing another (more difficult and odd type of adoption: embryo adoption) we got pregnant. Honestly it was a hard adjustment.

Well, long story short, little baby Eden dramatically burst onto the scene. Three kids is a lot, but it seemed we had room for at least one more. And adoption really is just amazing so we were dreaming of adopting from Africa or maybe from foster care, but figured we would wait until the kiddos got just a tad bit older. Then we find out, you'll never guess. Ok, well, you probably would. We were pregnant! We had another arrow for our quiver. Well, and just like the Lord, He gives more than we can ask or imagine (as well as more than we can handle so we learn to trust in His strength rather than our own) and he took my "unexplained infertility" and then gave me two more, a total of six!

I guess under the circumstances highlighting Eunice, Timothy's mom and her mom Lois is in order. Two incredible faith filled ladies whose faith multiplied for generations and even impacted the apostle Paul. He says this about them, *"I am reminded of your sincere faith, which first lived in your grandmother Lois and in your mother Eunice and, I am persuaded, not lives in you also."* 2 Tim. 1:5

Doing college ministry we hear a ton of horribly sad stories (many of which we get to see God redeem) but it is so super encouraging to hear a story of strong believers who left a legacy. I pray our kids will run after the Lord whole-heartedly and that Austin and I will finish strong (did you know only 30% of believers in the Bible finished strong, the same statistic is reality today) with a lasting, radical faith reproduced by our kids.

Faith is not a result of trying hard to have faith or hoping faith will stay unshakable. Faith comes from hearing and hearing from the Word of God. Basically, if you and I don't want to become part of the 70% who don't finish strong, we need to cling to Jesus and walk with Him moment by moment.

What does her story show you about God?

Write principles can you derive from her story?

What would it specifically look like for that to play out in your life this week?

Spend some time talking to the Lord about it what He showed you.

The Midwives
Living for Righteousness

"Then Joseph and all his brothers and all that generation died. But the Israelites were fruitful, increased rapidly, multiplied, and became extremely numerous so that the land was filled with them.

A new king, who had not known Joseph, came to power in Egypt. He said to his people, "Look, the Israelite people are more numerous and powerful than we are. Let us deal shrewdly with them; otherwise they will multiply further, and if war breaks out, they may join our enemies, fight against us, and leave the country." So the Egyptians assigned taskmasters over the Israelites to oppress them with forced labor. They built Pithom and Rameses as supply cities for Pharaoh. But the more they oppressed them, the more they multiplied and spread so that the Egyptians came to dread the Israelites. They worked the Israelites ruthlessly and made their lives bitter with difficult labor in brick and mortar and in all kinds of fieldwork. They ruthlessly imposed all this work on them.

Then the king of Egypt said to the Hebrew midwives, one of whom was named Shiphrah and the other Puah, "When you help the Hebrew women give birth, observe them as they deliver. If the child is a son, kill him, but if it's a daughter, she may live." The Hebrew midwives, however, feared God

and did not do as the king of Egypt had told them; they let the boys live. So the king of Egypt summoned the midwives and asked them, "Why have you done this and let the boys live?"

The midwives said to Pharaoh, "The Hebrew women are not like the Egyptian women, for they are vigorous and give birth before a midwife can get to them."

So God was good to the midwives, and the people multiplied and became very numerous. Since the midwives feared God, He gave them families. Pharaoh then commanded all his people: "You must throw every son born to the Hebrews into the Nile, but let every daughter live." Exodus 1:6-22

When asked to support a law to protect the preborn, a Christian leader once said, "I don't like being part of losing battles." That shook me to my core. Questions flooded my mind. A losing battle? Is doing what's right though it temporarily might not succeed really loosing? Should we only do what's right if we will succeed in the worlds eyes? Don't we ultimately win even if it doesn't look like it in the short term? Can it be that standing for what's right can never truly be losing? Is the point in life to glorify God (show the world what He is like), even if that doesn't look like success the way the world defines it? I'm grateful Jesus didn't think that way or any of the disciples for that matter.

In light of this leaders comment, these two ladies wow me. At the risk of not only losing the battle but their life, they

do what's right. A new king that didn't know Joseph came to power in Egypt. He freaked out because there was so many Israelites and feared they would take over. So he made them slaves. Now that is just confusing to me. How in the world did the Israelites succumb to that!? How does one person go up to another and say, now you're my slave and they say 'Ok'. I'm sure there's a lesson in there.

Anyway, the king's fear, bitterness and jealousy grew and led to death (just as sin does). He ordered that Shiphrah and Puah to kill every Hebrew boy that was born. Could you imagine being told to do that!? But this is what is said about these ladies, *"The midwives, however, feared God and did not do what the king of Egypt had told them to do; they let the boys live."* The result, *"So God was kind to the midwives and the people increased and became even more numerous."* All the people were blessed because these ladies feared God and did what was right.

What does their story show you about God?

Write principles can you derive from their story?

What would it specifically look like for that to play out in your life this week?

Spend some time talking to the Lord about it what He showed you.

Miriam
The Big Deal with Dishonor

Miriam and Aaron criticized Moses because of the Cushite woman he married (for he had married a Cushite woman). They said, "Does the Lord speak only through Moses? Does He not also speak through us?" And the Lord heard it. Moses was a very humble man, more so than any man on the face of the earth.

Suddenly the Lord said to Moses, Aaron, and Miriam, "You three come out to the tent of meeting." So the three of them went out. Then the Lord descended in a pillar of cloud, stood at the entrance to the tent, and summoned Aaron and Miriam. When the two of them came forward, He said:

"Listen to what I say:

If there is a prophet among you from the Lord,
I make Myself known to him in a vision;
I speak with him in a dream.
Not so with My servant Moses;
he is faithful in all My household.
I speak with him directly,
openly, and not in riddles;
he sees the form of the Lord.

So why were you not afraid to speak against My servant Moses?" The Lord's anger burned against them, and He left.

As the cloud moved away from the tent, Miriam's skin suddenly became diseased, as white as snow. When Aaron turned toward her, he saw that she was diseased and said to Moses, "My lord, please don't hold against us this sin we have so foolishly committed. Please don't let her be like a dead baby whose flesh is half eaten away when he comes out of his mother's womb."

Then Moses cried out to the Lord, "God, please heal her!"

The Lord answered Moses, "If her father had merely spit in her face, wouldn't she remain in disgrace for seven days? Let her be confined outside the camp for seven days; after that she may be brought back in." So Miriam was confined outside the camp for seven days, and the people did not move on until Miriam was brought back in. After that, the people set out from Hazeroth and camped in the Wilderness of Paran.

Numbers 12

Austin and I have a friend who we met in Durango and now does college ministry with his beautiful wife down in Texas. Eli and Mandy both love the Lord and want their lives to please Him in every way. God has gifted Eli with stellar musical abilities and in passionately teaching God's Word. Every time you get in a conversation with Eli, he wants to share with you something the Lord taught him.

We invited Eli to come to Denver and put on a concert and speak to our students. The week he came, we were dealing with a gossip problem going on with some of our students. God orchestrated things so beautifully to have Eli come at that exact point. Eli is possibly the most honoring person I know. It seems he uses every opportunity he can to honor people; to brag about them. He spoke to our leadership students about honor and taught them what it was and why it's such a big deal while he bragged on Austin and I while he was teaching. Then next day, I overheard some of the girls that were involved in the gossip bragging on other people!

When Eli lived in Durango, God was challenging him to be a man of honor. To not speak against his brothers and sisters in Christ, especially his leaders but instead be a warrior, a defender for them (Isn't it interesting that it is most common to talk bad about our authorities, when they are the exact ones God calls us to honor). He overheard his friend talking bad about the leader of the ministry and Eli actually went up and punched the guy. Not that I'm saying we just go around punching people but the gossip stopped and the group of guys started bragging on the leader and on others. Not long after that the ministry quadrupled in size. Honoring others has incredibly rewarding fruit, whereas gossip has incredibly destructive fruit.

Miriam is another example of dishonor and how serious God takes it. *"Miriam and Aaron began to talk against Moses because of his Cushite wife."* Miriam and Aaron were justified in thinking and saying he shouldn't have married the lady. But rather than talking to God and Moses,

they talked to each other about it and that did not make God happy. The Lord called them together and called Moses and Aaron out on their sin in a crazy way. He brags about Moses! God, God! The One who breathed the Milky Way, octopus and cherry trees into being and breathed life into the first man, Him! He brags about Moses.

Surely if God, the Perfect One can consider a person worth bragging about, so can we! Moses didn't deserve respect because he was so great, Moses deserved respect and honor because of what God thought about him and because of who made him.

Because honor is such a big deal to God, He gives Miriam leprosy and Moses pleads for her healing. God heals her but not until after seven days of discipline, meaning they couldn't move forward until her time of consequences was over. It just goes to show that sometimes things are delayed because of sin and the consequences of sin.

Dishonor, talking bad about your brothers and sisters in Christ and especially your leaders is a super big deal to God.

Do you take dishonor as seriously as God does? How do you know?

When you are in a situation where everyone is talking about someone, what do you do? What's your plan to get out of it?

What does her story show you about God?

Write principles can you derive from her story?

What would it specifically look like for that to play out in your life this week?

Spend some time talking to the Lord about it what He showed you.

Dinah

When Life is Bigger than you Imagined

*"Dinah, Leah's daughter whom she bore to Jacob, went
out to see some of the young women of the area. When
Shechem son of Hamor the Hivite, a prince of the region,
saw her, he took her and raped her. He became infatuated
with Dinah, daughter of Jacob. He loved the young girl and
spoke tenderly to her "Get me this girl as a wife," he told
his father Hamor.*

*Jacob heard that Shechem had defiled his daughter Dinah,
but since his sons were with his livestock in the field, he
remained silent until they returned. Meanwhile, Shechem's
father Hamor came to speak with Jacob. Jacob's sons
returned from the field when they heard about the incident
and were deeply grieved and angry. For Shechem had
committed an outrage against Israel by raping Jacob's
daughter, and such a thing should not be done.*

*Hamor said to Jacob's sons, "My son Shechem is strongly
attracted to your daughter. Please give her to him as a
wife. Intermarry with us; give your daughters to us, and
take our daughters for yourselves. Live with us. The land is
before you. Settle here, move about, and acquire property
in it."*

*Then Shechem said to Dinah's father and brothers, "Grant
me this favor, and I'll give you whatever you say. Demand*

of me a high compensation and gift; I'll give you whatever you ask me. Just give the girl to be my wife!"

But Jacob's sons answered Shechem and his father Hamor deceitfully because he had defiled their sister Dinah. "We cannot do this thing," they said to them. "Giving our sister to an uncircumcised man is a disgrace to us. We will agree with you only on this condition: if all your males are circumcised as we are. Then we will give you our daughters, take your daughters for ourselves, live with you, and become one people. But if you will not listen to us and be circumcised, then we will take our daughter and go."

Their words seemed good to Hamor and his son Shechem. The young man did not delay doing this, because he was delighted with Jacob's daughter. Now he was the most important in all his father's house. So Hamor and his son Shechem went to the gate of their city and spoke to the men there.

"These men are peaceful toward us," they said. "Let them live in our land and move about in it, for indeed, the region is large enough for them. Let us take their daughters as our wives and give our daughters to them. But the men will agree to live with us and be one people only on this condition: if all our men are circumcised as they are. Won't their livestock, their possessions, and all their animals become ours? Only let us agree with them, and they will live with us."

All the able-bodied men listened to Hamor and his son Shechem, and all the able-bodied men were circumcised. On the third day, when they were still in pain, two of

Jacob's sons, Simeon and Levi, Dinah's brothers, took their swords, went into the unsuspecting city, and killed every male. They killed Hamor and his son Shechem with their swords, took Dinah from Shechem's house, and went away. Jacob's other sons came to the slaughter and plundered the city because their sister had been defiled. They took their sheep, cattle, donkeys, and whatever was in the city and in the field. They captured all their possessions, children, and wives and plundered everything in the houses.

Then Jacob said to Simeon and Levi, "You have brought trouble on me, making me odious to the inhabitants of the land, the Canaanites and the Perizzites. We are few in number; if they unite against me and attack me, I and my household will be destroyed."

But they answered, "Should he have treated our sister like a prostitute?"

God said to Jacob, "Get up! Go to Bethel and settle there. Build an altar there to the God who appeared to you when you fled from your brother Esau."

So Jacob said to his family and all who were with him, "Get rid of the foreign gods that are among you. Purify yourselves and change your clothes. We must get up and go to Bethel. I will build an altar there to the God who answered me in my day of distress. He has been with me everywhere I have gone."

Then they gave Jacob all their foreign gods and their earrings, and Jacob hid them under the oak near Shechem.

When they set out, a terror from God came over the cities around them, and they did not pursue Jacob's sons. So Jacob and all who were with him came to Luz (that is, Bethel) in the land of Canaan. Jacob built an altar there and called the place God of Bethel because it was there that God had revealed Himself to him when he was fleeing from his brother.

Deborah, the one who had nursed and raised Rebekah, died and was buried under the oak south of Bethel. So Jacob named it Oak of Weeping.

God appeared to Jacob again after he returned from Paddan-aram, and He blessed him. God said to him:

Your name is Jacob;
you will no longer be named Jacob,
but your name will be Israel.

So He named him Israel. God also said to him:

I am God Almighty.
Be fruitful and multiply.
A nation, indeed an assembly of nations,
will come from you,
and kings will descend from you.
I will give to you the land
that I gave to Abraham and Isaac.
And I will give the land
to your future descendants.

Then God withdrew from him at the place where He had spoken to him.

Jacob set up a marker at the place where He had spoken to him—a stone marker. He poured a drink offering on it and anointed it with oil. Jacob named the place where God had spoken with him Bethel.

Genesis 34:1-35:15

Sometimes when things happen it's hard to get outside of our lens to see the big picture, to see how God is using it in other people's lives. Do you have a story (or have you heard of one) of something difficult the Lord allowed in your life where later you looked back and saw how it impact many others for the good?

Dinah's life is like that. Something awful happens to her, yet it is the very thing God uses to get Jacob, her dad, back to a place where remembered what was true about God and got a very clear picture of all God had done for him.

Genesis 34-35 tells Dinah's story. Basically this creep Shechem, a spoiled son of a ruler, sees Dinah, Jacob's daughter, and rapes her and then tells his dad to go get her to be his wife. Jacob heard about it and waited until her brothers got home. He was not being passive, indifferent or cowardly, but waiting because he needed their help to act. Shechem's dad, Hamor goes to Jacob's house and asks him to give him his daughter. Brothers walk in hear what happened and were furious but came up with a deceitful plan running ahead of God's judgement on the Canaanites. They gave Hamor their sister demanding all the men be circumcised. Three days later they went and rescued their

sister and killed Hamor and Shechem and every male and then carried off the women and children. Whoa huh! Talk about returning evil for evil.

But the hope comes is the first verse of chapter 35. *"Then God said..."* How beautiful that here, right in the middle of pain, hurt, lost dreams and hopes, bitterness, shame and guilt, God takes initiative to speak.

God tells Jacob to go back to the place where God had appeared to him before he was fleeing from his brother Esau. It's like moving from a desert to a garden, from an emergency room to a wedding reception. Years and years earlier Jacob was so self-absorbed he was deceitful to get his way. Now, he is able to look back and see how much God had changed his heart and life. He got to see his restore his relationship with his brother and got to see that just as God had said He would be with him, He was.

In chapter 33 and chapter 35, the name of the Lord is mentioned, but it is completely absent from chapter 34. Isn't that how it feels when we are going through times we feel completely hopeless. But the next chapter does come and we get to see God unfold the big picture. In chapter 35 El Shaddai, meaning God Almighty, the all-sufficient One and specifically emphasizes God's might over the frailty of man is mentioned 10 times. It's like the big finale. God comes through.

In our pain, in our suffering, God comes through and truly uses all things for the good of those who love God and are called according to His purpose. It truly is all about Him, the creator of the big picture.

What does her story show you about God?

Write principles can you derive from her story?

What would it specifically look like for that to play out in your life this week?

Spend some time talking to the Lord about it what He showed you.

Lot's Wife
Dealing with a Heart that Longs

The two angels entered Sodom in the evening as Lot was sitting at Sodom's gate. When Lot saw them, he got up to meet them. He bowed with his face to the ground and said, "My lords, turn aside to your servant's house, wash your feet, and spend the night. Then you can get up early and go on your way."

"No," they said. "We would rather spend the night in the square." But he urged them so strongly that they followed him and went into his house. He prepared a feast and baked unleavened bread for them, and they ate.

Before they went to bed, the men of the city of Sodom, both young and old, the whole population, surrounded the house. They called out to Lot and said, "Where are the men who came to you tonight? Send them out to us so we can have sex with them!"

Lot went out to them at the entrance and shut the door behind him. He said, "Don't do this evil, my brothers. Look, I've got two daughters who haven't had sexual relations with a man. I'll bring them out to you, and you can do whatever you want to them. However, don't do anything to these men, because they have come under the protection of my roof."

"Get out of the way!" they said, adding, "This one came here as a foreigner, but he's acting like a judge! Now we'll do more harm to you than to them." They put pressure on Lot and came up to break down the door. But the angels reached out, brought Lot into the house with them, and shut the door. They struck the men who were at the entrance of the house, both young and old, with a blinding light so that they were unable to find the entrance.

Then the angels said to Lot, "Do you have anyone else here: a son-in-law, your sons and daughters, or anyone else in the city who belongs to you? Get them out of this place, for we are about to destroy this place because the outcry against its people is so great before the Lord, that the Lord has sent us to destroy it."

So Lot went out and spoke to his sons-in-law, who were going to marry his daughters. "Get up," he said. "Get out of this place, for the Lord is about to destroy the city!" But his sons-in-law thought he was joking.

At daybreak the angels urged Lot on: "Get up! Take your wife and your two daughters who are here, or you will be swept away in the punishment of the city." But he hesitated. Because of the Lord's compassion for him, the men grabbed his hand, his wife's hand, and the hands of his two daughters. Then they brought him out and left him outside the city.

As soon as the angels got them outside, one of them said, "Run for your lives! Don't look back and don't stop anywhere on the plain! Run to the mountains, or you will be swept away!"

But Lot said to them, "No, my lords—please. Your servant has indeed found favor in your sight, and you have shown me great kindness by saving my life. But I can't run to the mountains; the disaster will overtake me, and I will die. Look, this town is close enough for me to run to. It is a small place. Please let me go there—it's only a small place, isn't it?—so that I can survive."

And he said to him, "All right, I'll grant your request about this matter too and will not demolish the town you mentioned. Hurry up! Run there, for I cannot do anything until you get there." Therefore the name of the city is Zoar.

The sun had risen over the land when Lot reached Zoar. Then out of the sky the Lord rained burning sulfur on Sodom and Gomorrah from the Lord. He demolished these cities, the entire plain, all the inhabitants of the cities, and whatever grew on the ground. But his wife looked back and became a pillar of salt.

Early in the morning Abraham went to the place where he had stood before the Lord. He looked down toward Sodom and Gomorrah and all the land of the plain, and he saw that smoke was going up from the land like the smoke of a furnace. So it was, when God destroyed the cities of the plain, He remembered Abraham and brought Lot out of the middle of the upheaval when He demolished the cities where Lot had lived.

Genesis 19:1-29

I use to work at Denny's one night a week. I saw it as a way to pray for people I normally never would have. (It was the hang out for the young teenage Satanists in my town.No joke.) Something that always struck me was almost every old couple who came in would order the same meal as each other. It just goes to show the more you are around someone, the more you become like them, something Scripture makes very clear.

We have every reason to believe Lot's wife had similar values and desires as her husband, the friend of the world. Right before her story, Jesus and two angels appeared to Abraham and as a ninety-nine year old man, he runs to serve them, and finds out the Lord is going to destroy Sodom. Abraham pleads for the Lord not too destroy it if there is found ten righteous. There is not ten righteous and the two angels go to rescue Lot before the city is burned. The angels approach the city and Lot strongly insisted they stay with him (knowing how vile the city is). That night men from every part of the city, young and old surround his house yelling for Lot to send the men so they could rape them.

What would you do at this point? What would you do if you were Lot's wife?

Lot goes out to the men and says, *"No, my friends. Don't do this wicked thing. Look, I have two daughters who have never slept with a man. Let me bring them out to you, and you can do what you like with them. But don't do anything to these men..."* Oh my word, what a creep!

Now what would you do if you were Lot's wife?

The angels pull him back in the house and struck all the men with blindness so they couldn't figure out how to get in the house. Smart move. They explain the Lord is about the burn down the city and him, his wife and daughters have to go. But Lot hesitates and the angels yanked him and his wife by the arm and led the family out of the city saying, *"Flee for your lives! Don't look back, and don't stop anywhere in the plain!..."*

"The Lord rained down burning sulfur on Sodom and Gomorrah... destroying all those living in the cities-and also all the vegetation in the land. But Lot's wife looked back, and she became a pillar of salt." She looked back. It just goes to show how a spiritual decline happens slowly yet drastically. We are capable of being so far from God that we desire and long for places that in any other state of mind we would recognize as horrid. Just as Lot's wife, apart from the Lord we are capable of spiritual blindness and a deceitful heart that longs for evil. How desperate we are for the Lord's strength and our hearts and desires to be aligned with His. It comes down to a heart willing to yield, to surrender to the Lord and let Him fill us with His Spirit and enablement to live the life only He can live through us.

What does her story show you about God?

Write principles can you derive from her story?

What would it specifically look like for that to play out in your life this week?

Mother of Thunder
When you want for your Kids

Then the mother of Zebedee's sons approached Him with her sons. She knelt down to ask Him for something. "What do you want?" He asked her.

"Promise," she said to Him, "that these two sons of mine may sit, one on Your right and the other on Your left, in Your kingdom."

But Jesus answered, "You don't know what you're asking. Are you able to drink the cup that I am about to drink?"

"We are able," they said to Him.

He told them, "You will indeed drink My cup. But to sit at My right and left is not Mine to give; instead, it belongs to those for whom it has been prepared by My Father." When the disciples heard this, they became indignant with the two brothers. But Jesus called them over and said, "You know that the rulers of the Gentiles dominate them, and the men of high position exercise power over them. It must not be like that among you. On the contrary, whoever wants to become great among you must be your servant, and whoever wants to be first among you must be your slave; just as the Son of Man did not come to be served, but to serve, and to give His life—a ransom for many."
Matthew 20:20-28

On our drive to the grocery store this morning, my boys
Uriah and Asher started arguing in the car about if they
could build a house or not. It turned into the perfect
opportunity to talk about how we exist for God and we
need to do with our lives what He wants us to do, not just
what we want to do. I told them that whatever we do, it has
to be for the purpose of making God known and listed a
bunch of examples. Asher decided on being a spy sneaking
into closed countries to tell bad guys about Jesus (boy after
my own heart). Uriah decided on dressing up in costumes
and telling people about Jesus.

Intellectually, thinking about them doing dangerous things
for Jesus is awesome. But yet I worry so much about things
like them drowning or getting kidnapped or hit by a car.
This morning as I read about James and John's mom, the
Lord convicted me about my worry of them.

She wanted what was best for her boys. She was bold and
knew that Jesus had the authority to give them a good life,
to let them sit on his right and his left. It is pretty admirable
that she approached Jesus and asked a bold thing for her
sons. The problem was she saw success through the lens of
the world. She wanted them to have power, reputation and
authority how this world recognizes it. She didn't
understand the kingdom of God in relation to her sons. She
didn't connect that the way up for them is the way down.
She saw through this short speck of life lens believing as
though this life was the end all. She had no idea marytrdom
and exile for the Gospel was what she was asking for her
sons-for that equals fame in heaven. If she knew, would she

have desired and pleaded for *that* for her kids? It's so easy to equate success with painlessness and lack of suffering.

The Lord stirred my thoughts. What are my desires for my kids? Are my desires limited to this life? Are they short-sided, lacking eternal perspective? Am I hoping for them a good reputation and safety in this life or in the one to come? Do I desire safety for them more than I desire God to be glorified in their life? Do I want the podium of greatness for them now at the expense of being bankrupt in heaven? If the way for God to be most glorified in them is through suffering, do I want that?

Oh Lord forgive me for gripping the kids you've entrusted to me too tightly. Help me trust You with them. And even in that surrender there's a fear You'll let something bad happen to them if I loosen my grip. But You did let something bad happen to James and John and in the grand scheme, in eternal view, it was beautiful. You used their lives to glorify You to maximum potential and it was worth it. Why is it so hard to let go? The what ifs seem to have a powerful hold over me. Lord, I come to You just as the mother of Zebedee's sons did and entrust my children to You. Instead of asking for their greatness, I ask that You use their life for Your greatness. And give me grace to accept whatever that may look like. Help me daily loosen my grip of them and cling tighter to You.

What does her story show you about God?

Write principles can you derive from her story?

What would it specifically look like for that to play out in your life this week?

Spend some time talking to the Lord about it what He showed you.

Martha

Having a Martha Faith in a Mary World

"Now a man was sick, Lazarus, from Bethany, the village of Mary and her sister Martha. Mary was the one who anointed the Lord with fragrant oil and wiped His feet with her hair, and it was her brother Lazarus who was sick. So the sisters sent a message to Him: "Lord, the one You love is sick."

When Jesus heard it, He said, "This sickness will not end in death but is for the glory of God, so that the Son of God may be glorified through it." Now Jesus loved Martha, her sister, and Lazarus. So when He heard that he was sick, He stayed two more days in the place where He was. Then after that, He said to the disciples, "Let's go to Judea again."

"Rabbi," the disciples told Him, "just now the Jews tried to stone You, and You're going there again?"

"Aren't there 12 hours in a day?" Jesus answered. "If anyone walks during the day, he doesn't stumble, because he sees the light of this world. If anyone walks during the night, he does stumble, because the light is not in him." He said this, and then He told them, "Our friend Lazarus has fallen asleep, but I'm on My way to wake him up."

Then the disciples said to Him, "Lord, if he has fallen asleep, he will get well."

Jesus, however, was speaking about his death, but they thought He was speaking about natural sleep. So Jesus then told them plainly, "Lazarus has died. I'm glad for you that I wasn't there so that you may believe. But let's go to him."

Then Thomas (called "Twin") said to his fellow disciples, "Let's go so that we may die with Him."

When Jesus arrived, He found that Lazarus had already been in the tomb four days. Bethany was near Jerusalem (about two miles away). Many of the Jews had come to Martha and Mary to comfort them about their brother. As soon as Martha heard that Jesus was coming, she went to meet Him. But Mary remained seated in the house.

Then Martha said to Jesus, "Lord, if You had been here, my brother wouldn't have died. Yet even now I know that whatever You ask from God, God will give You."

"Your brother will rise again," Jesus told her.

Martha said, "I know that he will rise again in the resurrection at the last day."

Jesus said to her, "I am the resurrection and the life. The one who believes in Me, even if he dies, will live. Everyone who lives and believes in Me will never die—ever. Do you believe this?"

"Yes, Lord," she told Him, "I believe You are the Messiah, the Son of God, who comes into the world."

Having said this, she went back and called her sister Mary, saying in private, "The Teacher is here and is calling for you."

As soon as she heard this, she got up quickly and went to Him. Jesus had not yet come into the village but was still in the place where Martha had met Him. The Jews who were with her in the house consoling her saw that Mary got up quickly and went out. So they followed her, supposing that she was going to the tomb to cry there.

When Mary came to where Jesus was and saw Him, she fell at His feet and told Him, "Lord, if You had been here, my brother would not have died!"

When Jesus saw her crying, and the Jews who had come with her crying, He was angry in His spirit and deeply moved. "Where have you put him?" He asked.

"Lord," they told Him, "come and see."

Jesus wept.

So the Jews said, "See how He loved him!" But some of them said, "Couldn't He who opened the blind man's eyes also have kept this man from dying?"

Then Jesus, angry in Himself again, came to the tomb. It was a cave, and a stone was lying against it. "Remove the stone," Jesus said.

Martha, the dead man's sister, told Him, "Lord, he's already decaying. It's been four days."

Jesus said to her, "Didn't I tell you that if you believed you would see the glory of God?"

So they removed the stone. Then Jesus raised His eyes and said, "Father, I thank You that You heard Me. I know that You always hear Me, but because of the crowd standing here I said this, so they may believe You sent Me." After He said this, He shouted with a loud voice, "Lazarus, come out!" The dead man came out bound hand and foot with linen strips and with his face wrapped in a cloth. Jesus said to them, "Loose him and let him go." John 11:1-44

Martha gets kind of a bad rap because of her task oriented nature. In Luke 10 we see Mary sitting at the feet of Jesus spending time with Jesus while Martha fumes about how Mary isn't helping her prepare dinner for the house full of guests. Well, this story seems to overshadow something pretty awesome about Martha, her faith. So I'm going to brag on the out-shined by her sister lady for a bit.

John 11 pins Mary and Martha's differences against each other and Luke 10 shows Mary to be a feeler and Martha to be a thinker. The beauty of this story is that Jesus shows Himself in so many ways. Not only does He show Himself to be boss over death but He communicates with the Martha the thinker and feels with Mary the feeler. Jesus makes it obvious that He meets us where we are.

But this story is where Martha's faith shines. Her brother, Lazarus just died and her and her sister had asked Jesus to come days earlier. Jesus intentionally stayed in the town He

was in a couple more days, actually waiting for Lazarus to die so He could show His awesomeness. Nobody of course understood that. I mean, that's even hard to grasp today, seeing the Lord wait in showing off.

Jesus arrives and sweet Martha is the one who goes out to meet Him. Mary doesn't go to Jesus, she stays in her grief and disappointment. Isn't that easy to do. Martha's first words to Jesus, *"Lord, if you had been here, my brother would not have died. But I know that even now God will give you whatever you ask."* How awesome is that! I'm so proud of her. Her brother just died and instead of seeing Jesus as incapable, she does the opposite. It seems she actually knows that Jesus can raise her brother from the dead. Jesus uses it as a teachable moment to give her a secret about His character. Beautiful! But instead of persisting in asking questions, she gets a bit know-it-all and getting to hear more from Jesus about what He's going do stops there.

Martha's faith stays steady and strong even in the hardest of times. She concludes her little conversation with Jesus, *"I believe that you are the Messiah, the Son of God, who was to come into the world"* written in the perfect tense indicates a fixed and settled faith; I have believed and will continue to believe.

Martha, the task-oriented, thinker is a great example to us of faith. But so often this world offers the example of having faith in our feelings and experiences instead of the truth of God's Word.

What does her story show you about God?

Write principles can you derive from her story?

What would it specifically look like for that to play out in your life this week?

Spend some time talking to the Lord about it what He showed you.

The Phoenician Widow
Blinding Effects of Shame

Now Elijah the Tishbite, from the Gilead settlers, said to
Ahab, "As the Lord God of Israel lives, I stand before Him,
and there will be no dew or rain during these years except
by my command!"

Then a revelation from the Lord came to him: "Leave here,
turn eastward, and hide yourself at the Wadi Cherith where
it enters the Jordan. You are to drink from the wadi. I have
commanded the ravens to provide for you there."

So he did what the Lord commanded. Elijah left and lived
by the Wadi Cherith where it enters the Jordan. The ravens
kept bringing him bread and meat in the morning and in
the evening, and he drank from the wadi. After a while, the
wadi dried up because there had been no rain in the land.

Then the word of the Lord came to him: "Get up, go to
Zarephath that belongs to Sidon and stay there. Look, I
have commanded a woman who is a widow to provide for
you there." So Elijah got up and went to Zarephath. When
he arrived at the city gate, there was a widow woman
gathering wood. Elijah called to her and said, "Please
bring me a little water in a cup and let me drink." As she
went to get it, he called to her and said, "Please bring me a
piece of bread in your hand."

But she said, "As the Lord your God lives, I don't have anything baked—only a handful of flour in the jar and a bit of oil in the jug. Just now, I am gathering a couple of sticks in order to go prepare it for myself and my son so we can eat it and die."

Then Elijah said to her, "Don't be afraid; go and do as you have said. But first make me a small loaf from it and bring it out to me. Afterward, you may make some for yourself and your son, for this is what the Lord God of Israel says, 'The flour jar will not become empty and the oil jug will not run dry until the day the Lord sends rain on the surface of the land."

So she proceeded to do according to the word of Elijah. Then the woman, Elijah, and her household ate for many days. The flour jar did not become empty, and the oil jug did not run dry, according to the word of the Lord He had spoken through Elijah.

After this, the son of the woman who owned the house became ill. His illness became very severe until no breath remained in him. She said to Elijah, "Man of God, what do we have in common? Have you come to remind me of my guilt and to kill my son?"

But Elijah said to her, "Give me your son." So he took him from her arms, brought him up to the upper room where he was staying, and laid him on his own bed. Then he cried out to the Lord and said, "My Lord God, have You also brought tragedy on the widow I am staying with by killing her son?" Then he stretched himself out over the boy three

times. He cried out to the Lord and said, "My Lord God, please let this boy's life return to him!"

So the Lord listened to Elijah's voice, and the boy's life returned to him, and he lived. Then Elijah took the boy, brought him down from the upper room into the house, and gave him to his mother. Elijah said, "Look, your son is alive."

Then the woman said to Elijah, "Now I know you are a man of God and the Lord's word from your mouth is true."
1 Kings 17

I've heard it said when life squeezes someone it gives you an opportunity to see what's inside of them.

1 Kings 17 tells an incredible story, one that shocks me every time I read it, of a lady who gets squeezed. The Lord has brought drought on the land to bring His people back to a true understanding of who He is. During these three years, the Lord provided for Elijah through a brook and ravens bringing him food. The brook dried up and the Lord told him to go ask a widow for food. That itself is shocking. The Lord directed him to a women, a widow no less, a non-Israelite widow women to find sustenance. Wow. God can use whoever He'd like to provide for us.

I would love to know this lady. I would love to hear her story. But my favorite part would be the end, this chapter where God pursues her and peels back the layers of blindness and opens her eyes to what He is really like.

Elijah meets her as she is gathering sticks to make her last meal for her and her son. She is fully convinced she is going to die after that when Elijah tells her to give him her last meal. Would you ever say yes? I'm pretty sure I wouldn't, but she does and gets to see God miraculously provide for her and her son.

This sweet, young mom understands Elijah is a "man of God", a prophet but it is an intellectual knowledge and the Lord wants her to know Him on a deeper level so He allows for her life to be squeezed a bit harder. Her son dies. Her only son, after losing a husband and apparently all of her other family, the only thing she has left is taken from her. As we normally do in hopelessness, she pointed the finger at Elijah exposing her heart covered in shame. *"What do you have against me, man of God? Did you come to remind me of my sin and kill my son?"*

Her shame was keeping her from truly knowing, real-I know you because we do life together know, God. So the Lord pursues and hits her shame head on with the reality that He is the one who gives life and rescue from the power of death. He raises her son from the dead. The very first instance of raising the dead recorded in Scripture. Then young widow says, *"Now I know that you are a man of God and that the word of the Lord from your mouth is the truth."*

God allows things in our lives to break through our hard hearts to help us see Him as He truly is. He wants us to know Him, to experientially know, not just intellectually know Him. That we might know Him in the we did life together type of way, for this is eternal life.

What does her story show you about God?

Write principles can you derive from her story?

What would it specifically look like for that to play out in your life this week?

Spend some time talking to the Lord about it what He showed you.

King Lemuel's Mom
Bragging on Others

When you hear about the Proverbs 31 women, what do you think and feel?

There is aa lot of talk about the intimidating women of virtue. But what I find impressive is the lady who is not intimidated by her or jealous of her, but rather describes and brags about her to her son. King Lemuel's mother is an example of someone who has an accurate perspective of herself enabling her to see others for what they are.

Since the fall, the tendency of our heart is to one up people. To have to be better than someone and if we aren't, then it's easy to default to the poor me, I'm the worst mentality. Humility is seeing ourselves as we truly we are, no more no less. Humility enables us to the see the gifts of others without comparing ourselves and being jealous. It enables us to appreciate the strengths of others without feeling bad about ourselves.

But as with all things good, humility is a gift from the Lord, not something we conjure up by trying hard. And the Lord, the Giver of good things wants to give us things that please Him, things like humility. So why not take a minute to ask Him to develop that more deeply in you today?

When was the last time you honored/bragged about someone behind their back about character qualities you don't possess? (In an excited for them and amazed at God way, not a wow, aren't they awesome and I'm just scum type of way.) Perhaps that would be a good step of faith to take today by the strength of the Holy Spirit.

So what qualities can you brag on about other people? (Which really is bragging about God, since everything good comes from God and He's the One that gave those qualities to them anyway.) Why not head on over to facebook and tell them how beautiful that quality is on their wall or shoot them a text?

What does her story show you about God?

Write principles can you derive from her story?

What would it specifically look like for that to play out in your life this week?

Spend some time talking to the Lord about it what He showed you.

The Sinful Woman
The Making of a Heroine

You probably have guessed that I love college students. After working with them since January 2003, equaling over 22,000 hours ministering to them I think it's fair to say I know them. I deeply understand them and I appreciate them. But when you haven't heard their stories and felt their pain it's easy to point fingers at their outward appearance or mannerisms.

Not too long ago some volunteers were helping at one of our student retreats and I overheard them saying how the girls needed to hear a talk on modesty. Now, there is nothing wrong with talks on modesty but the girls on the retreat these ladies were talking about were not Christians and had been deeply hurt in the past by Christians. They struggled with self-hate and for the first time were semi-open to the idea that Jesus could actually care about them. A talk on modesty is pretty much the last thing "those girls" needed.
It is so easy for us to see the outside of people and make judgements about where we think they need to be and point fingers instead of really getting into their life and hearing their story and walking through it with them.

Luke 7:36-50 tells us a beautiful story of a prostitute who saw who Jesus and was moved to action. She made a

choice to give Him something incredibly precious and valuable to her, her perfume, her livelihood. The most important thing to a prostitute was their perfume, which this lady held in this alabaster jar. Her devotion was sacrificial, intentional and courageous.

Yet from the moment Jesus entered Simon's house, he did not give him a basin to wash His feet and did not greet Him with a kiss. This would be like bringing a special guest into your home and not opening the door for them, taking their coat and saying hello. What Simon did was very offensive. I wonder if he was slightly jealous of Jesus and that is why he went out of his way to try to show Jesus was nothing special. Perhaps this is why the prostitute is crying wondering, "Don't they know who He is? Why are they treating Him this way?"

I love how Jesus doesn't just sweep things under the carpet, but addresses attitudes and actions. He brings this offense to Simon's attention as well as bring truth to the lies he was believing. A humble man at this point would apologize for his lack of respect and thank the woman for compensating for his rudeness. But Simon, not able to recognize his faults is only able to point the finger at the outwardly sinful woman.

Still talking to Simon, Jesus turns to the woman. How beautiful! He is looking right into her eyes and starts bragging on her in front of the entire room of people. Who in these men's worlds would be the most undeserving of honor? A prostitute woman, but Jesus seizes the

opportunity to brag on her because of her faith.

This story is incredibly shocking to the men in that room because not only does Jesus praise and honor a despised women, but goes on to make her the noble hero. And His honoring of her publicly brings with it the benefit of restoring her to community.

There is a need to come alongside the people God has put in our life and help them overcome sin. Galatians 6:1 says *"Brothers, if someone is caught in a sin, you who are spiritual should restore him gently. But watch yourself, or you also may be tempted."* We are called to correct our brothers and sisters in Christ but the word restore in Greek means to mend a net or set a broken bone. It implies being careful and gentle, not a pointing finger but a loving arm wrapped around. To bring truth in the context of grace by going through the mess with them. After they turn back to Jesus in submission, they need to be restored to community and the community needs to receive them without holding back love or respect. They deserve to be treated with respect just like Jesus treated the prostitute.

"Then one of the Pharisees invited Him to eat with him. He entered the Pharisee's house and reclined at the table. And a woman in the town who was a sinner found out that Jesus was reclining at the table in the Pharisee's house. She brought an alabaster jar of fragrant oil and stood behind Him at His feet, weeping, and began to wash His feet with

her tears. She wiped His feet with the hair of her head, kissing them and anointing them with the fragrant oil.

When the Pharisee who had invited Him saw this, he said to himself, "This man, if He were a prophet, would know who and what kind of woman this is who is touching Him— she's a sinner!"

Jesus replied to him, "Simon, I have something to say to you."

"Teacher," he said, "say it."

"A creditor had two debtors. One owed 500 denarii, and the other 50. Since they could not pay it back, he graciously forgave them both. So, which of them will love him more?"

Simon answered, "I suppose the one he forgave more."

"You have judged correctly," He told him. Turning to the woman, He said to Simon, "Do you see this woman? I entered your house; you gave Me no water for My feet, but she, with her tears, has washed My feet and wiped them with her hair. You gave Me no kiss, but she hasn't stopped kissing My feet since I came in. You didn't anoint My head with olive oil, but she has anointed My feet with fragrant oil. Therefore I tell you, her many sins have been forgiven; that's why[a] she loved much. But the one who is forgiven little, loves little." Then He said to her, "Your sins are forgiven."

Those who were at the table with Him began to say among themselves, "Who is this man who even forgives sins?"

And He said to the woman, "Your faith has saved you. Go in peace." Luke 7:36-50

What does her story show you about God?

Write principles can you derive from her story?

What would it specifically look like for that to play out in your life this week?

Spend some time talking to the Lord about it what He showed you.

About the Author

Laura her husband have six kids and have been missionaries to college students since 2003. She serves as the Women's Development Coordinator with Master Plan Ministries and has discipled over two hundred women, led over forty Bible studies and speaks to college and women's groups. She is the Founder of the internationally popular blog MissionalWomen.com and has authored six books, including an award winning twelve week Bible Study on First Samuel, *Beholding Him, Becoming Missional, Reach; How to Use Your Social Media Influence for the Glory of God*, and *A Devotional Journey through Judges.*

Other books and resources by Laura

A Creative, Interactive Resource for Small Group Leaders

Deeper connections are critical to a Small Group and creating them can be a challenge. So here is a resource—creative ideas and content—to help your Small Group make those connections.

Why Connect Cards?

Small groups provide an atmosphere where great growth can take place but it takes intentionality to think through how to help group members connect with God, each other and the Great Commission in a deep and meaningful way. **The Connect Cards** provide training, questions and ideas to ensure each of these elements are present each week to make not only a deep and meaningful group but also an influential one.

How it Works

The Connect Cards deck has four essential elements: Connect with Scripture (for the leader), Connect with God (prayer), Connect with Each Other (group interaction), and Connect with The Mission (ministry). There are eleven cards per section, with forty-four cards total.

Each week during your small group Bible Study, chose one card from each section. (There are eleven cards per section) All four categories combined (depending on the size of your group) should last about 30-45 minutes to your group time. If you are short on time, you can do one or two cards a week to go through or you can choose to go through one section/card at a time.

Tailor fit this creative deck to fit your group.

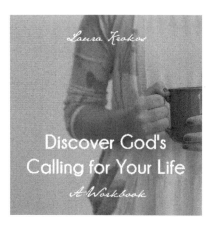

Knowing your calling will help you live a confident, effective life that please the Lord. The content and questions in this workbook will help you know what God desires of your life and by the end of this workbook you will have a clearly defined calling by which to measure all your activity in this life and practical goals to begin (or continue) to walk out the calling the Lord has for you.

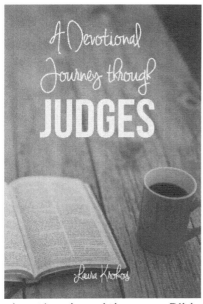

Practical, insightful and relatable 250 page in depth devotional study with great personal stories. Each day is short enough to be able to read and have time to process the personal application questions.

Customer Reviews

Brilliantly done devotional! *In the Christian literary world there are devotionals and there are Bible studies, and then there is Laura Krokos' A Devotional Journey Through Judges, which is a little bit of both! Her title is apt, as this book truly is a journey. Unlike most devotionals that contain random verses from different parts of the Bible, Journey Through Judges provides consecutive verses beginning at the first verse of Judges and ending with the last, giving the reader a cohesive theme to follow throughout the devotional. The reader is able to gain knowledge of the book of Judges while benefitting from Laura's insight and personal tidbits. I am thoroughly enjoying this devotional. I would recommend it to anyone wanting a devotional that is a bit different from the traditional coffee table edition, or anyone that would like a Bible study that does not require much time. She did a beautiful job on this book! Great work! -Shara Nelson*

Bible Study Journals

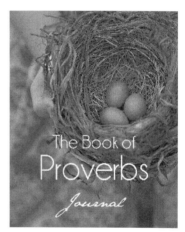

Made in the USA
Columbia, SC
10 January 2023

75892460R00043